T0085694

YOGA
While
You
Wait

Judith Stoletzky

Photography by Markus Abele

TILLER PRESS

New York London Toronto Sydney New Delhi

Contents

What are you waiting for?

Aren't we all waiting for something? For happiness. For inner peace. For personal growth. For inspiration. For a kind word. For better times. For ovulation. For the 6 pm commuter train that is running late again. Whatever it is, we all are waiting for the end of useless waiting. Et voilà! From now on waiting is useful—because you will be waiting in a yoga pose. No more excuses. From now on, nobody can talk themselves out of practicing yoga because of a lack of time, yoga pants in the laundry, or a dislike of lotus flowers, mantra

singing, or incense. Real yoga doesn't take place in a yoga studio anyway. It takes place in real life, which at times is rich and at other times dull, but always truly remarkable. And yoga pants aren't mandatory. Yoga works anytime, anywhere, everywhere. It fits into the tiniest gaps in your day, between A and B, in the middle of nowhere, and in the middle of the night. Even when you are in limbo or stressed out, your meandering mind can find calm and your tense body can enjoy a stretch. Don't keep them waiting any longer.

Having fun.

All is easy.

Maybe you think you won't be able to practice yoga unless you can bend like a contortionist. Let's hum a soothing *Ommmm* now. Just breathing, watching, standing, and sitting are already yoga . . . and if performed mindfully, yoga practice feels like the first time even for the most advanced yogi.

No license for Lotus.

Not every body is naturally elastic. Each and every body is different, proportions are unique, and often bone structure limits our range of motion. That's why the yoga poses shown in this book are on the easy side, or are not executed to the full expression shown in many yoga teaching books; such images usually intimidate the reader. That the lotus, of all poses, has become the symbol of yoga practice is a misunderstanding that is not good for the knees.

Do it daily.

Even though this book is always in a jocular mood, it is still suitable for earnest practice. Each exercise comes with detailed instructions and can be adapted to the body, not vice versa. The exercises are not strenuous and will not bother anyone (who's not already bothered). Some exercises are so subtle that others won't even notice that you're practicing. More expressive postures reinforce the useful skill of staying within yourself in the present moment.

Hares and rabbits. Heroes and warriors.

Expert connoisseurs of yoga are invited to take full advantage of their flexibility. Please forgive this book for using names from different schools of yoga and different translations from Sanskrit whenever it serves a joke.

Practice, practice, practice.

Beginners and advanced yogis can use this book seriously in order to have fun with yoga. The next time you have to wait, grasp the opportunity to practice yoga for a minute rather than grasping your smartphone and disappearing for an hour.

Always a good idea.

There are some insider tricks that will make your practice more powerful, more effective, and—most of all—safer!

1. Breathe. Concentrate on both the inhale and the exhale, preferably through your nose. Whenever you notice that you are holding your breath or it seems constricted, step back and take it easy.

2. Press every part of your body that is in contact with the ground firmly into it. This energizes your muscles and makes your pose more solid. And it automatically stabilizes the often weak core.

3. If your muscles aren't warmed up, please take care when stretching.

4. Always lift your sternum. Always. That will lift your spirits too. Instantly.

Chair

utkatasana

Waiting for the next one.

Strengthens practically everything, especially your core and your knees. Empowers your will and stamina.

Sitting is the new smoking. Praise the uncertainties of public transportation and be happy that a bus stop isn't a business-class lounge. When there is no seating option in sight, this chair will make it even more uncomfortable. You could get really angry in *utkatasana*. Translated from Sanskrit, *utkatasana* means "fierce posture." It ignites your inner fire and makes your will as strong as an ox. Why not just let the next bus whiz by and choose to enjoy this powerful feeling for a while?

Making sitting work.
Stand up straight. Feet and knees touching. As you inhale, stretch your arms upward. With an exhalation, sit down on an imaginary chair. Activate your abdominal muscles. Tuck your tail. You are probably pulling your shoulders up. Let them sink again. Breathe! Stay in this posture for at least five long breaths and enjoy the heat it produces. If you like your chair even more uncomfortable, squeeze the palms firmly together above your head and look up. Stand up with a straight back as you inhale and let your arms sink to the sides. Close your eyes. Enjoy.

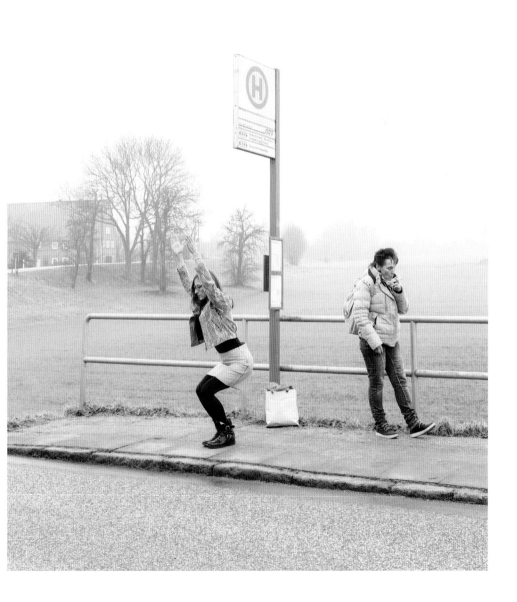

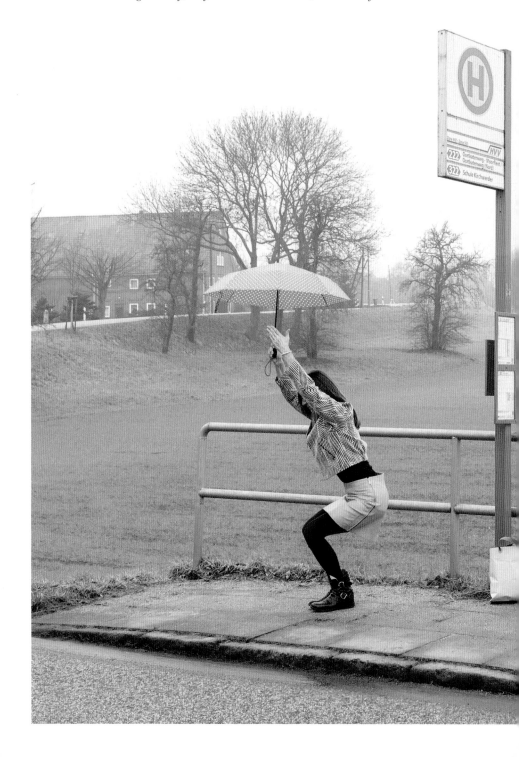

And since we are sitting so nicely, why not take the next bus, or the one after that?

Boat

navasana

Waiting for ~~lunch~~ supper.

Helps to pass wind. Strengthens hip flexors, back, and abdomen. Good for the neck and shoulders too.

The smelt is a comical little ocean fish that smells like cucumber. It is best rolled in rye flour, fried with bacon, and served with baked potatoes and apple sauce. Each spring, the smelt swims upriver to spawn. When exactly that happens, only the smelt knows for sure. Given the fat content of his favorite food, our smart fisherman will use this undetermined latency period to flatten his tummy. Balancing on the seat of his pants, he will stimulate the flow of bile and also strengthen his abdominal muscles. When the smelt finally arrives, the fisherman will no longer need back support, and fishing will have earned its reputation as a sport.

Nothing fishy about this, old sport.
Sit on the ground with your legs straight. Place your hands behind your buttocks with your fingers pointing forward and your shoulders back. Lean back and lift the sternum, keeping your lower back straight. Tighten the abdominal muscles. Breathe. Create length between the pubic bone and sternum. Balance your weight between your sit bones and your tailbone. Breathe. Raise your feet and pull your knees toward your chest. Stretch your arms out at shoulder height. Feel the power all the way to your fingertips. Straighten your knees, extend your feet, and flex your toes. Remember to keep your lower back straight. Keep breathing. Easier version: Bend your legs and/or place your hands behind your hips. Or, as pictured, use support, but hang in there, mate.

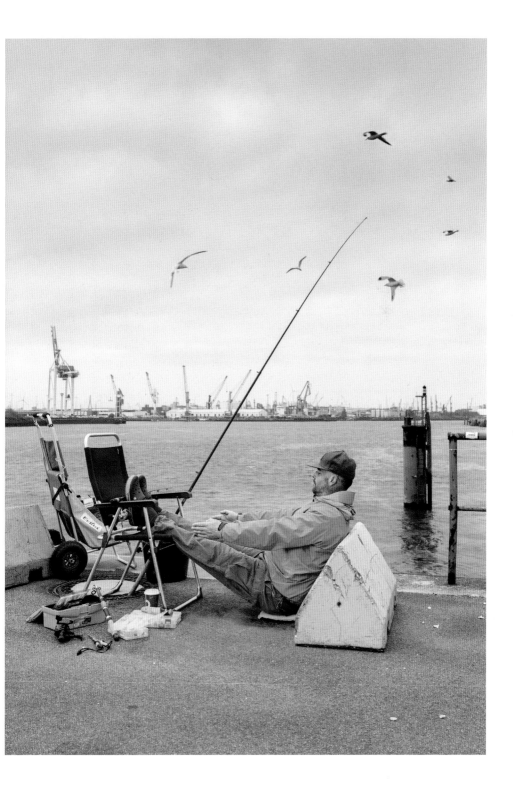

Airplane

vimanasana

Waiting for a breakthrough.

Strengthens ankles, legs, and back. Enhances balance, equanimity, and concentration. Strengthens the arms and lower abdominal muscles.

Novalis, a romantic German poet and philosopher, said that all barriers are there to be overcome. We say: "Nonsense!" Stop, for heaven's sake, and pause. Enjoy the energizing intermission provided by your local public transportation. Train yourself to live your life to the fullest, and celebrate the happy circumstance of not being on a full train. Spread your wings to full span as you gracefully circle your destination, and from a higher standpoint contemplate the concept of waiting. First on the right leg, then on the left.

Ready for takeoff.
Stand straight with your feet parallel and hip-width apart. Activate your leg muscles and straighten your spine and pelvis. Flaps down. (Draw your shoulder blades down your back.) Stretch your arms out to the sides at shoulder height, extending the fingertips. Lower the torso parallel to the floor, keeping the back straight and sternum lifted, activating the abdominals and pelvic muscles. Shift your weight to one leg and lift the other, extending it straight back, with the toes facing down. Keep the pelvis parallel to the ground. Eyes to the ground, neck long. Breathe deeper in case of turbulence, or let your raised leg gently touch down. Prepare the other leg for departure.

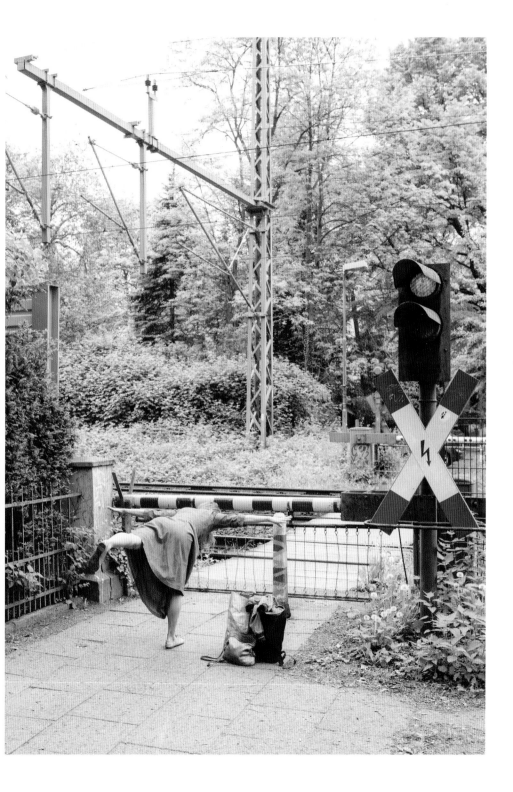

Shoulderstand

salamba sarvangasana

Waiting for catharsis.

Stimulates the thyroid and metabolism. Stretches the spine and strengthens the neck and shoulders. Refreshes the legs, clears the eyes, and rejuvenates the complexion.

A visit to the laundromat can be a purifying experience not only for dirty clothes but also for murky moods. True catharsis during a single wash cycle is possible! Shoulderstands speed up your circulation by several cycles per minute. The gentle pressure on the throat stimulates the thyroid, while your legs and feet enjoy the pure bliss of having the upper hand. For stronger cleansing action, soak yourself in this all-purpose pose for several minutes. When you leave the laundromat, the world will be fresh and clean, your thoughts will be fluffy and fragrant, your gaze will be remarkably soft, and your old self will look brand-new.

Wash and wear.
Lie on your back with your legs outstretched. Place your arms alongside your body, palms downward, neck straight. Tighten the abs. Press your arms and hands downward and raise your legs straight above your head. Roll your weight onto your shoulders and support your rib cage with your hands. Your fingers point toward your waist, thumbs toward your belly button. Keep your elbows hip-width apart. Straighten and lengthen your back. Stretch your legs above your shoulders, perpendicular to the floor. Rotate your thigh muscles inward. To come down, fold your knees toward your forehead. Roll your torso onto the ground. When your hips touch the ground, straighten your legs and slowly lower them, strongly engaging your abdominals. Cycle complete!

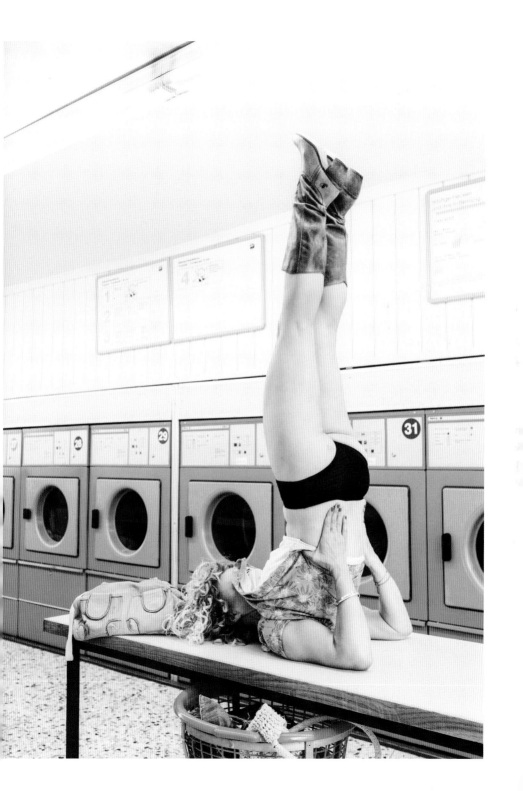

Lion

simhasana

Waiting to get unblocked.

Loosens emotional tension. Relaxes the jaw, lifts the face, prevents wrinkles. Strengthens the voice.

When the traffic of life gets stuck, don't just sit there like a deer in the headlights. You're in the driver's seat! In a complete standstill, we are able to direct our energies and change lanes to accelerate our journey into tranquility. Even rush hour on an LA freeway can turn into a powerful transformative experience if you do this: inhale deeply. Let it all out and drive onto the detour with a scream. No matter if Mustang, Jaguar, or Beetle. The lion even works in a Lotus.

Become a lamb.
Usually the lion is practiced sitting on the heels, but it works as well sitting behind a wheel. Lift the shoulders to your ears, roll them back, and let them drop. Stretch your arms out in front of you and rest your hands on the thighs, knees, wheel, or dashboard. Lengthen the spine. Lift the sternum. Pull your shoulder blades toward the pelvis. Close your eyes. Bow the head toward your chest and inhale deeply. With one single and furious movement, throw your head back. Push your chest forward, open your eyes wide, and gaze between your eyebrows. Stick out your tongue toward your chin and roar like a lion. Repeat until you feel calm and peaceful.

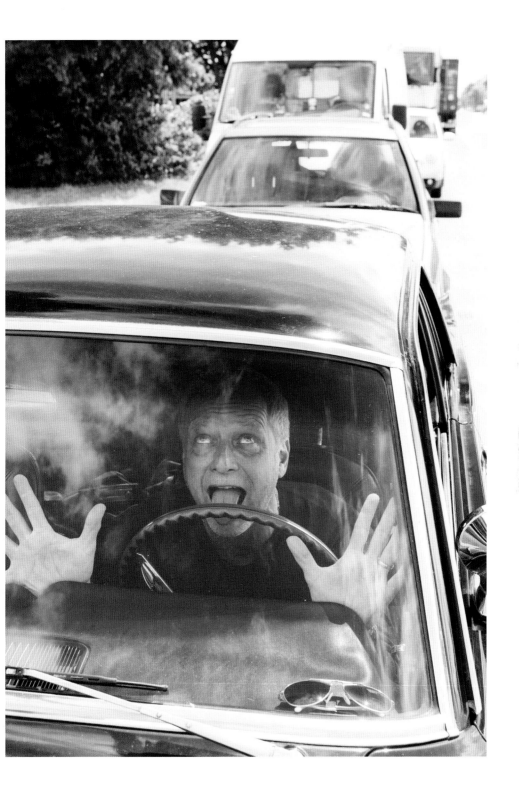

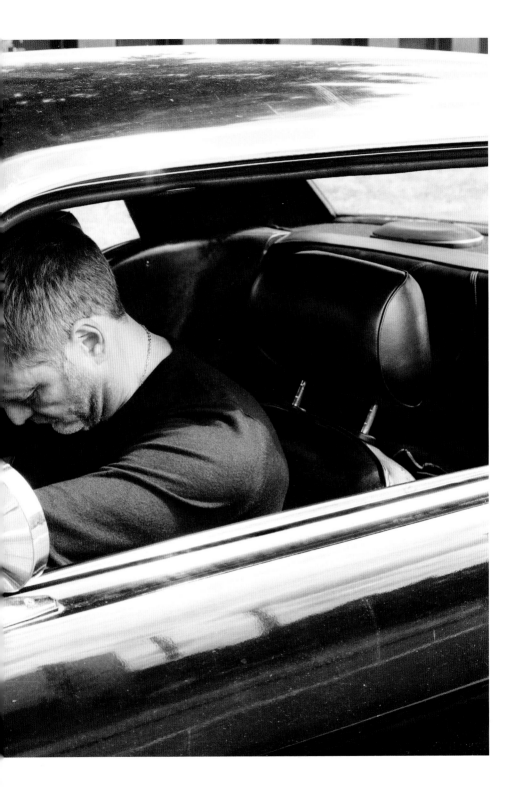

Half moon

ardha chandrasana

Waiting for infinity.

Massages the waist. Good for the digestive tract. Balances the back muscle groups. Promotes a graceful posture.

What distinguishes pedestrians from mindful walkers is their attitude. The pedestrian impatiently but obediently stops at a red light, even if there isn't any other traffic that needs regulation, whereas the mindful walker joyfully welcomes this blissful pause. The pedestrian honors law and order; the mindful walker honors the here and now. While promenading under the night sky with its infinite number of heavenly bodies, the mindful walker gently surrenders to something greater than the human need to control all earthly matters. By bending your own celestial body into the shape of a half moon, you not only create heavenly space in your flanks but also expand the oh-so-brief and evanescent present moment. And you and the cosmos become one.

Be a shining example.
Stand straight and strong with your shoulders relaxed, ankles, knees, hips, shoulders, and crown in a straight line. The big toes are touching, the outer edges of the feet parallel. Tighten your quads and press your feet into the ground. Inhale deeply as you extend your arms sideways and up above your head. Interlace your fingers. Breathe into your sides. Extend your arms further upward while lowering your shoulders. Inhaling, bend your body to the left, engaging your buttocks, pelvic, and abdominal muscles to protect your lower back. Hold for three breaths. Inhale deeply as you come back to the straight upright position. Now, turn right.

Warrior II

virabhadrasana II

Waiting to go up.

Strengthens shoulders, arms, abdominals, and legs. Opens the heart and hips. Produces courage and clarity.

If you want to elevate yourself, you not only have to define your goals, you also need strength and stamina. It is therefore also important to pause on the journey. Sit out a round. Verify what floor you're on, and see if your focus is still right. Is your core centered? How much weight is on your shoulders? Any blockages? Both the warrior II posture and a high proportion of spandex in your business suit will increase flexibility and upward mobility. Now you are guaranteed to push the right buttons and rise to the occasion as you sink deeper into the pose.

To the top.
Stand in mountain pose (p. 28). With a deep breath, jump into a wide stance, feet parallel. Stretch your arms to the side at shoulder height. Turn your right foot ninety degrees so that your heel points at the arch of your left foot. Bend your right knee until it is in line with your ankle. Be careful not to let your knee shift to the inside, but make sure your second toe is visible right under your kneecap. Press the outer rim of your left foot into the ground. Stack your pelvis and shoulders and align them with your legs. Feel a stretch in your inner thighs and groin. Tuck your tailbone, lift your pubic bone, and lift your chest. Move your shoulders away from your ears. Sink deeper into the pose. Your third eye focuses on the imaginary goal you see beyond your right hand. Hold for sixty seconds. Switch sides.

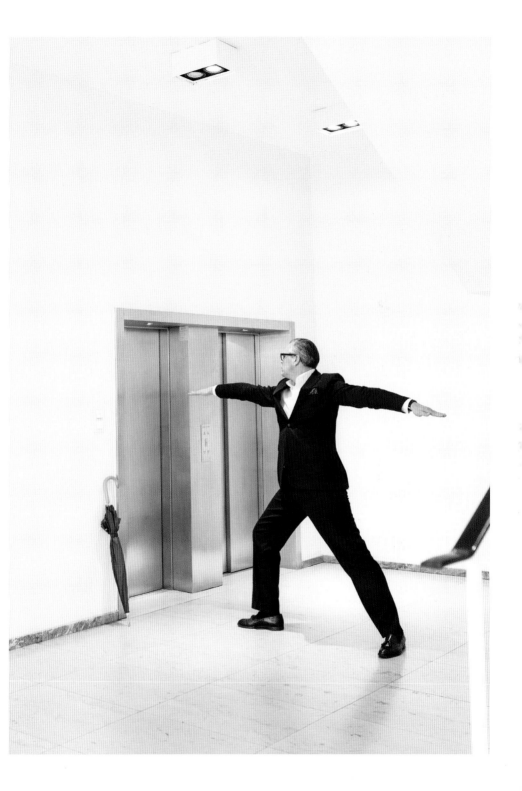

Palm tree

talasana

Waiting for paradisiacal conditions.

Stretches the spine and loosens blockages at the ends of the nerves. Strengthens the ankles. Stretches the abdominals. Creates balance.

Where summer temperatures get up to only 63°F, even a northern community garden can morph into a tropical paradise for a person of buoyant imagination. Until the moment the food is finally sizzling on the grill over the hot coals, grillmaster and guests are well advised to surrender completely to this hot fantasy by making their bodies as long as the palms of Polynesia. By stretching in this fashion, they not only shorten the waiting time, they also widen their bellies and create space for the perfectly balanced, smoked diet that will soon delight their exquisitely attuned taste buds: vegan sausages, tofu burgers, kale and quinoa hot dogs, and yummy meatless balls, for instance.

Turn your attention upward.
Stand straight, feet parallel and hip-width apart, toes facing forward. Focus on a point on the ground or at eye level to support your balance. Interlace your fingers, turn your palms upward, and extend your arms completely over your head. Actively lengthen your spine and flanks. Lift your chest, lowering your chin slightly. Activate your legs, buttocks, and pelvic muscles. Inhale as you rise up on your toes. Your heels will want to move outward; work against that with the power of your will and your muscles. After five deep breaths, slowly lower your arms to your sides and consider a second round.

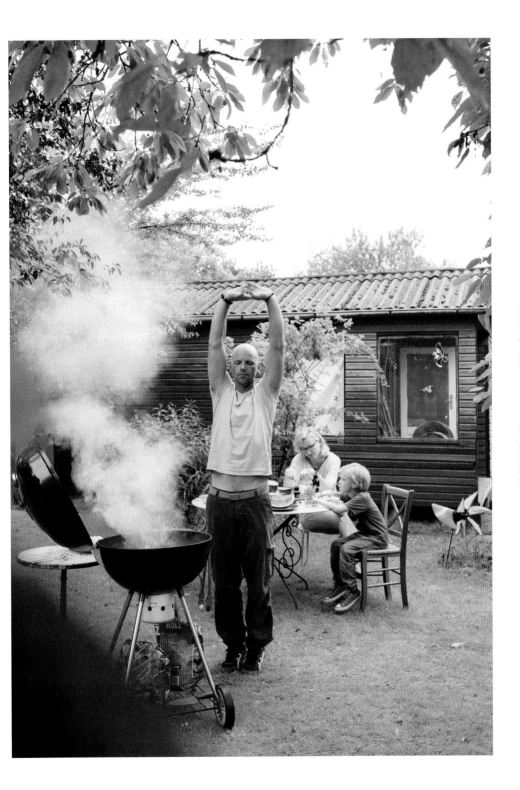

Mountain

tadasana

Waiting for better times.

Straightens the spine.
Boosts self-confidence.
Increases energy.
Grounds, centers, and
calms a wandering mind.

Waiting for the sun can cause over sensitive life-forms to lose ground as early as November. Some of us are in danger of falling into deep, dark places in the depths of winter. Mountain pose helps us to stoically confront and endure circumstances that simply are what they are. If you start practicing mountain pose in autumn, nothing will be able to shake you. Not the endless winter, the all-too-short summer, or 97.3 percent of all the other things that are beyond your control. Like waiting for Godot. Waiting for the swimming pool to open. Waiting for the pizza delivery guy. Or waiting for humanity to smarten up.

Standing orders.
Stand with your big toes and heels together. Distribute your weight evenly on both feet. Flex the arches of your feet, just barely bending your knees. Engage your glutes, tipping the tailbone slightly forward to relax your lower back. Tighten the abdominal muscles. Raise your shoulders to your ears and then roll them back and down. Extend your collarbones and raise your sternum, keeping your chin parallel to the floor. Activate your arms and hands. Turn your palms forward, fingertips reaching for the ground. Breathe deeply into your belly. Trust yourself to close your eyes—and begin to see the light.

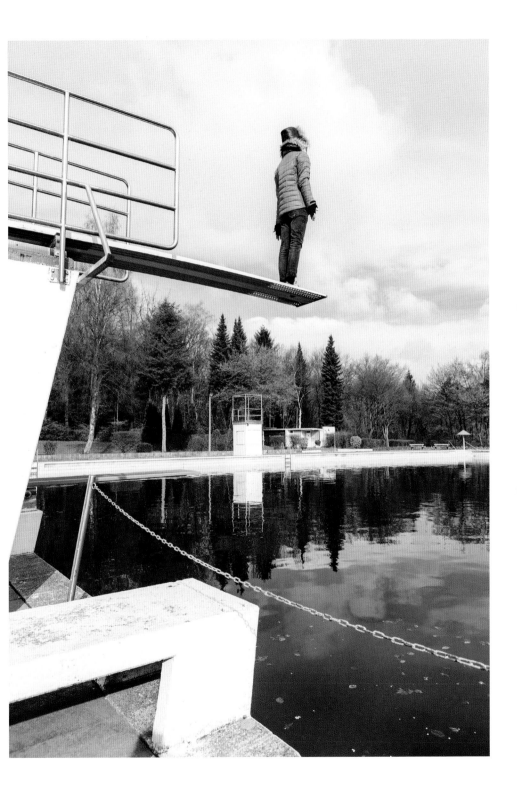

Half seated twist

ardha matsyendrasana

Waiting for the common cold.

Makes the spine supple, expands the rib cage, and allows deep breathing. The gentle abdominal massage promotes digestion.

Human closeness is often an imposition. If there is no cover from germ bombardment, mindfully turn your attention to the haze of finely diffused secretions exploding from your neighbor's nose and you will find peace and serenity in the present moment. You will truly understand the term "going viral," and with this fresh coating of insight, waiting will not feel half as tenacious as the mucus in your bronchi. Isn't it amazing how quickly your perspective can shift? It's nothing to sneeze at! And never forget, deep breathing is not only in the here and now but also in the there and then, always a healthy idea.

Say Aaaaaaaaah!
Sit on a chair with your spine straight. Do not lean back against the chair. Press your feet firmly into the floor, hip-width apart. Position your thighs and shins at right angles to each other. Straighten your pelvis slightly and pull your belly button inward. Inhaling deeply, lengthen your spine and turn left as you exhale. Press your right hand against the outside of your left thigh and pull yourself deeper into the twist. Place the fingertips of your left hand behind your back. Allow your head to follow your shoulders, but only as far as is comfortable. After five deep breaths, switch sides.

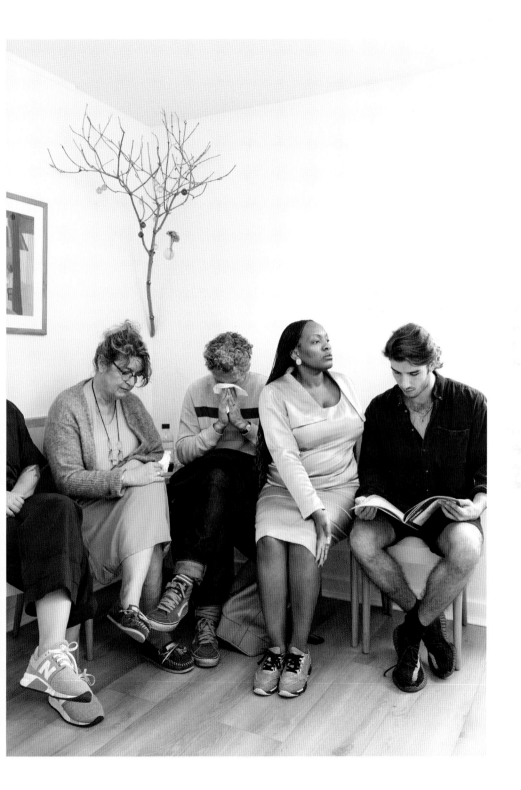

Tree

vrikshasana

Waiting for the summer yellowbird.

Promotes inner balance. Good for flat feet and weak ankles. Calms the nervous system. Great for a sexy rear end.

The yellow warbler, also known as the summer yellowbird (*Setophaga petechia*), belongs to the family of wood warblers and lives in the vertical structural elements of wetland plant communities. Prospects of an encounter with the bird grow with the viewer's capability to adapt to the biotope of their subject. If you are inconspicuous like a tree in the reeds, maybe a willow or a mangrove, and if you gently sway your treetop branches in the winds and lightly rustle your ears, you may see the yellow warbler. Maybe, perhaps, sometime. Possibly. Stand steady. Chirp.

Tree nursery.
Stand straight, feet touching. Imagine a straight line running from the crown of your head to your heels. Don't arch your back! Microbend your knees to get your leg muscles working. Position your chin parallel to the floor. Place your palms together in front of your chest or rest them on your hips. Focus on a spot in front of you or at eye level. Shift your weight onto one leg and find your balance. Rest the other foot next to the ankle, or on the inside of your lower leg or thigh, toes facing down. Open the bent knee to the side while keeping the hips pointed straight forward. As an option, lift your arms over your head, spread them in a V-shape, and draw your shoulders down. Breathe. Switch legs.

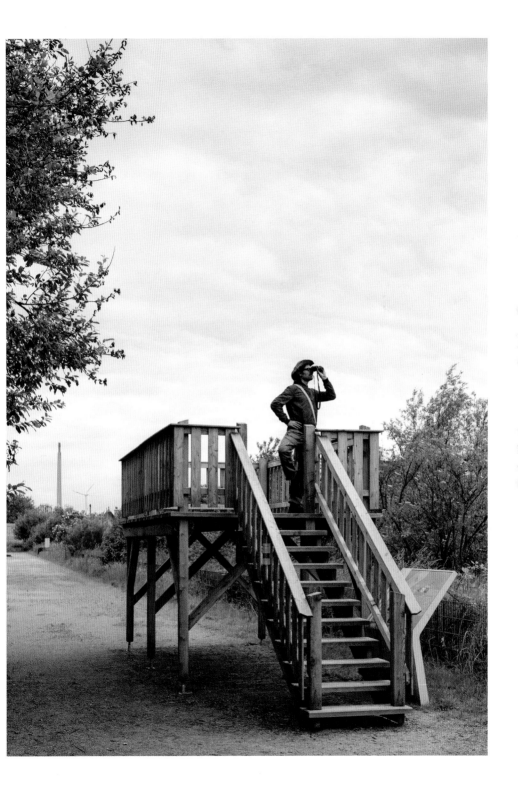

Hero I

virabhadrasana 1

Waiting for the song of the sirens.

Strengthens the legs. Stretches the groin and hip flexors. Strengthens the shoulders and arms, and widens the chest. Provides self-confidence, courage, and stability. Keeps the inner fire burning.

The legend goes that Virabhadra, who this position is named for, was a godlike hero. It is said that he was created from a lock of Shiva's hair and that he looked terrifying. In this respect, he has absolutely nothing in common with the handsome and chiseled firefighters of today. It is unknown how the hero Virabadhra made himself useful during his lifetime, but he contributed one clear example to humankind. Thanks to him, the constant struggle of earthlings to reach for the stars—even between calls of duty—has found an alarmingly impressive form.

How to become Superman.
From tadasana (p. 32), jump into a wide stance. The feet are parallel, facing straight forward. Rest your hands on your hips. Turn the left foot 90° outward, the right foot 45° inward. Turn your torso—including the pelvis—to the left and align your upper body with the front leg, both facing straight forward. Press the back foot firmly into the ground and straighten the knee. Bend the front leg until the knee is aligned with the ankle. Don't let the knee fall to the inside. Lift the pubic bone toward the belly button to avoid compression in the lower back. Lift the chest and pull in the lower ribs. Inhaling, raise your arms straight up over your head, while pulling the shoulders down and away from the ears. Look up between your hands. Hold for at least three deep breaths (or until you've got more important things to do) and then switch sides.

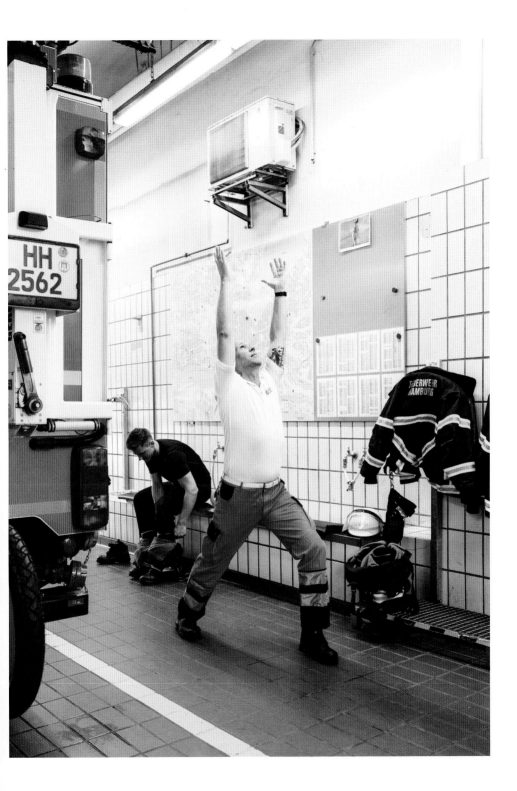

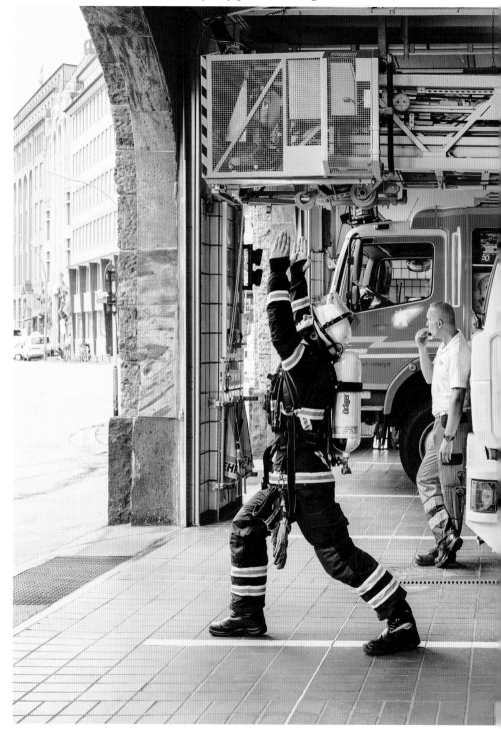

This is what it looks like when there is a fire of goodness burning in the heart.

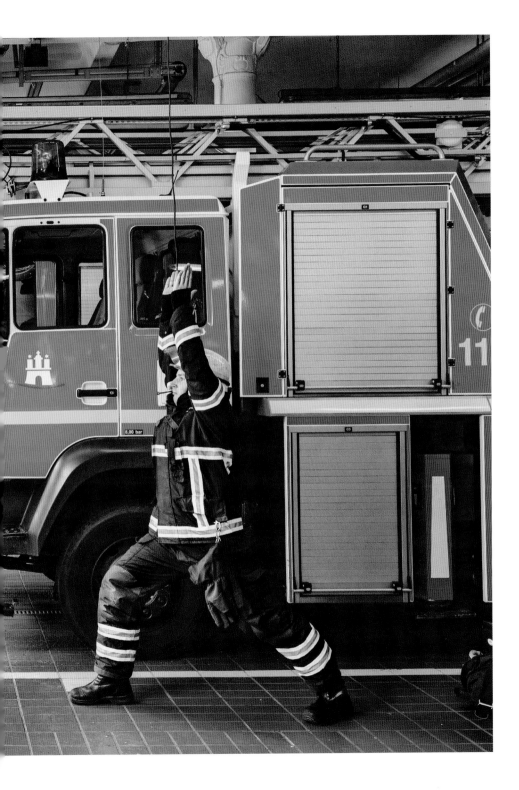

Intense dorsal stretch

pashimottanasana

Waiting to paint the town.

Intense stretch for the back of the body, especially the buttocks and hamstrings. Revitalizes the kidneys, liver, and pancreas.

Nothing represents a greater challenge for the well-groomed and self-determined woman of today than idle waiting for her nail polish to dry enough that it allows her to spring into action and come to grips with what needs to be handled. Even though her hands and feet are tied in this forward bend, this is exactly the moment—after some deep, deep breaths—to completely let go, with no aspirations. The buttocks, legs, and back are stretched; the neck, head, and mind relax; and the sunny world effortlessly unfolds in front of the third eye, perfectly aligned.

Not just a dry run.
Sit up straight on the floor with your legs extended. Keep your feet touching, toes pointing up, heels pressed into the ground. Rest your hands on your thighs. Lengthen your back and slowly move forward, bending from the hips. Do not round your shoulders. Slide your hands along your legs. Grab your toes, ankles, calves, or the floor and gently push your back forward. Your sternum takes the lead as you reach for your toes. Do not allow your upper back to round unless your belly can rest on your thighs with ease. If the stretch in your thighs is too intense to keep your back straight, bend your knees.

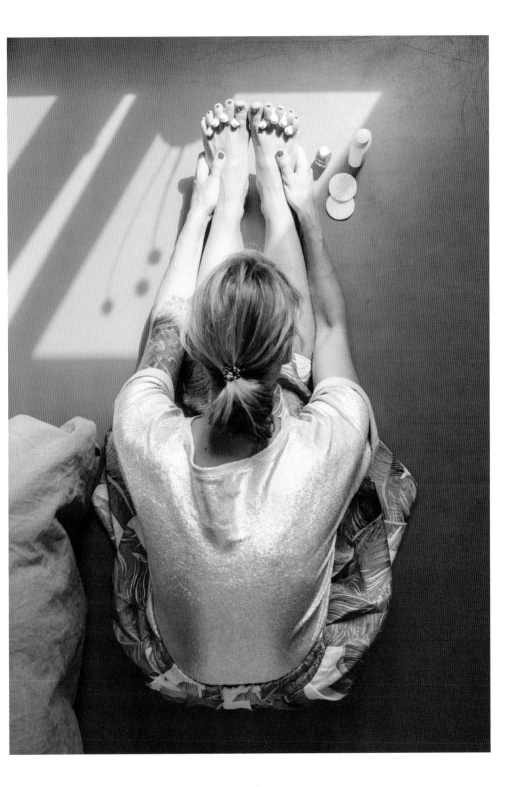

Half bird of paradise

ardha svarga dvijasana

Waiting for the final curtain.

Strengthens ankles, knees, and quads of the standing leg and stretches the groin. Enhances balance and the ability to focus.

It may take a while for the final curtain to fall in the performance of *Dressed to Thrill*. The waiting shopping consultant can then reflect at greater length on the significance of appearance. This location is custom-made for learning to reduce our vanity—and the elegant asana bird of paradise is the perfect fit for the occasion. Those who squeeze themselves into this pose like a woman who squeezes herself into a Little Black Dress that is too small will soon learn that an oversized ego has the power to not only destroy seams but also tendons, ligaments, and inter vertebral discs.

Looking really dapper.
Sit in a deep squat (p. 42). Stretch your right arm above your head and bring it to your back, palm facing out. The left hand dives in front of and under the left thigh. Hands clasp. Slowly shift your weight onto the right foot and bring the left foot closer to the right. Focus on a point on the floor that isn't moving. Press the right foot into the ground and shift your weight completely onto the right leg. Carefully lift the left foot off the floor and straighten the right leg. Lift your gaze. Straighten your back as much as possible. Lift the chest. Breathe. If you can, stretch the left leg completely. If you want to, but cannot, don't. To come out of the pose, reverse the steps, slowly.

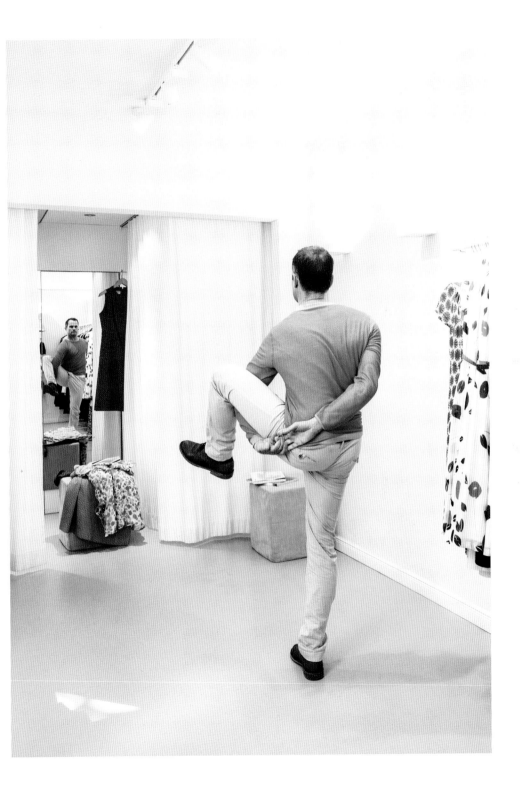

Garland

malasana

Waiting to grow.

*Grounds and promotes
serenity. Strengthens
the thighs and ankles.
Stretches the groin, and
promotes digestion.*

If you want to practice patience in order to tend the garden of your soul, try planting yourself among young chrysanthemum seedlings. From here, let your hips sink deeper and deeper and deeper into the present moment. Breathing profoundly into your root chakra will ground you; your eyes will not find a single reason to feel hurried to do anything. Not even beyond the horizon. Your faith in the ways of the world will grow, and you will come to a real understanding of this fact: when the time for Conaco Yellow, Allouise Pink, and Mrs. Jessie Cooper has come, they will bloom.

Get down!
Stand with your feet hip-width apart, toes turned outward. Bring your palms together in front of your chest. Exhale and sink into a deep squat. Pressing your palms together and your elbows against your inner thighs, straighten your back and increase the stretch in your groin. Lift your sternum. Drop your hips deeper toward the ground. Shift your weight forward as far as you can without letting your ankles collapse inward. If you cannot bring your heels down, use high heels or any other support to ground them. With a small, medium, or large serving of patience, you might someday master this practice with your feet together—you may even be able to bend forward deeply enough to give Mother Earth a little kiss.

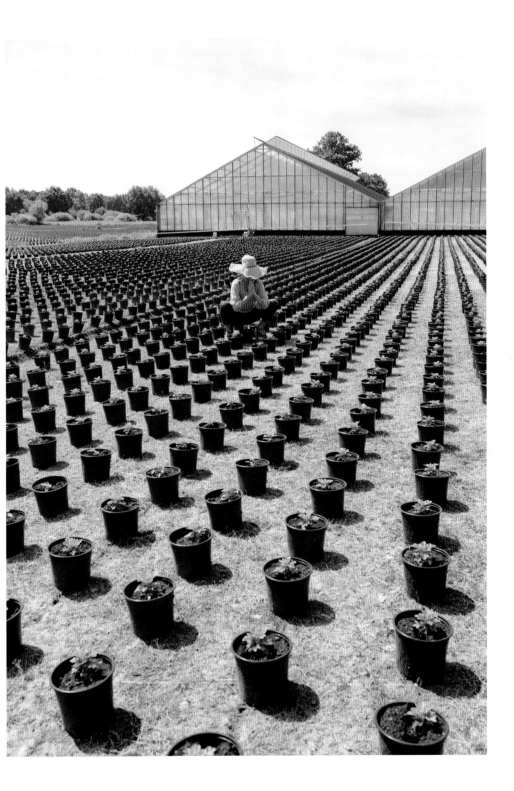

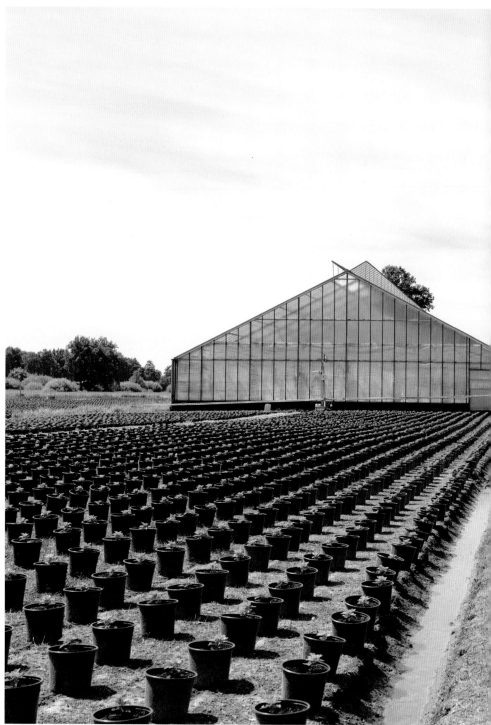

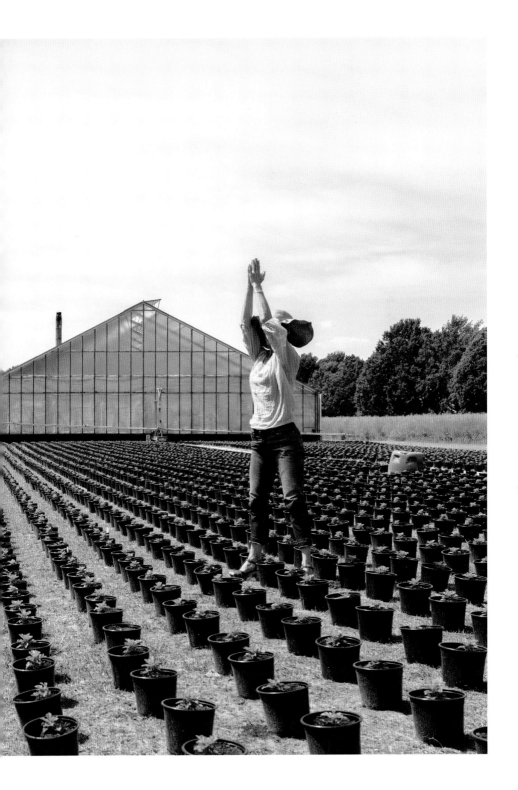

Half pyramid

ardha parsvottanasana

Waiting for a sign.

Promotes stability. Strengthens the groin, hips, shoulders, and back. Stretches the back of the legs. Stimulates the liver and stomach and promotes self-reflection.

We all have a longing to be seen. Even more, we have a huge hunger to be fully acknowledged—by the ones we love, and also by the waitstaff. However, making others responsible for the satisfaction of our most existential needs always leads to disappointment, sooner or later. It is therefore no mistake to frequently check on what's in our internal pantry. In considering all that we have, maybe we will find a little humility on one of the shelves, a snack of gratitude for the fact that we do not lack anything substantial. We may even find some hearty confidence that we will receive what we deserve. Sooner or later.

The secret of half pyramid.

Start in mountain pose (p. 28). Step the left foot back about three feet, maintaining the hip-width spread of the feet. Point your right foot straight forward, and turn your left foot forty-five degrees outward. Press your feet into the ground and straighten your legs. Rest your hands on your hips and square your pelvis by pulling your right hip back and pushing your left hip forward. Inhale, lift your sternum, and pull your shoulder blades together. As you exhale, bend over your front leg, maintaining a straight back. Your torso should hover parallel to the ground. If your shoulders are flexible, your hands may clasp your elbows or each other. After three nourishing breaths, activate your abdominals and come up with a straight back. Change sides for the second course.

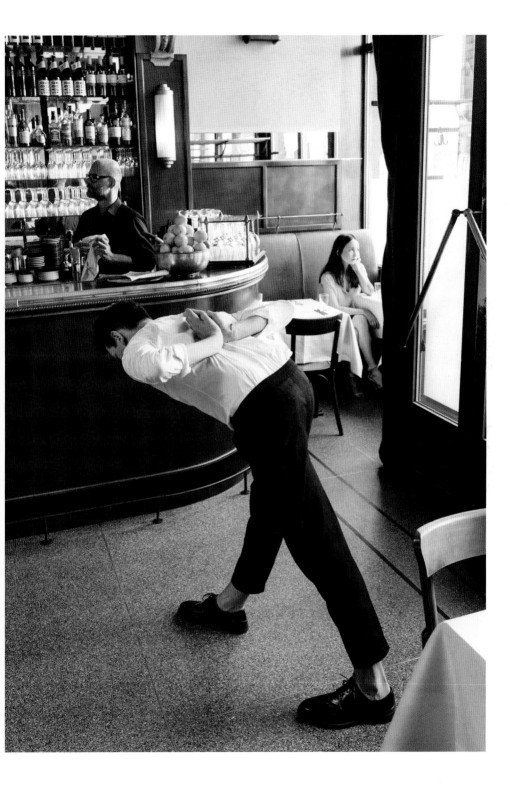

Rag doll

uttanasna (variation)

Waiting for a golden moment.

Provides relief for the lower back. Loosens tension in the shoulders.

When you have made it to the cashier without losing focus on your shopping list, you might—in the presence of the ultimate temptations— give in completely. Is there any greater bliss than taking a gentle forward bend and emptying your overstimulated mind of all thoughts about the delicious options in front of you? Is there anything sweeter than the sensation of deep relaxation in the upper back after a successful practice of self-discipline? Generously let others who want to rush go by. These people will pay for all the things they don't need, and one fine day they will know the true cost of their impatience.

Priceless.
Place your feet hip-width apart, toes facing straight forward. Distribute your weight evenly on both feet, not just on the heels or toes. Rest your hands on your hips. Bend your knees slightly and bend forward from the pelvis over your legs. Lengthen your lower back. Let go. Relax your neck muscles and let your head hang. Let your torso gently swing from side to side. To sink deeper, you may clasp your elbows. To move out of the pose, bring your hands back to your hips, activate your abdominals and back muscles, and come up as you inhale.

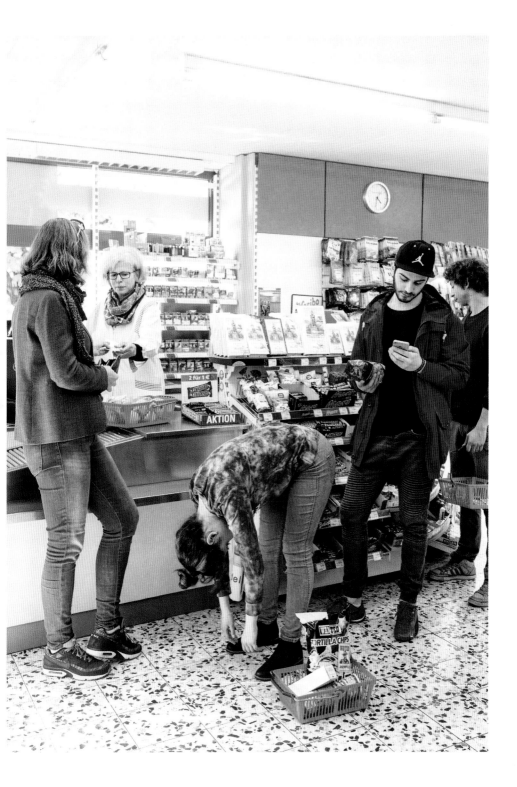

Cosmic egg

brahmandasana

Waiting for your BFF.

Improves balance. Gives a feeling of security. Provides stability when you are at an emotional low point

The realization that you are not missing anything even when you are all by yourself is a profound and affirming lesson that can never be learned too early. There will always come a point when everyone you know who could be a fun playmate is busy balancing their own ups and downs instead of starring in their useful role as the completion of yourself. Those who can look to themselves for entertainment and support are quickly able to lift their spirits and level their vision on their own, transforming even the most challenging, highly unstable situations—a lonely Sunday afternoon, for instance—into well-rounded experiences.

Egging yourself on.
Sit on the floor. Pull your knees up and hug them to your chest. Slowly shift your weight backward until you are balancing between your sit bones and your tailbone. If you can, lift your toes off the floor. Lower your forehead toward your knees, or even rest it on them. Close your eyes and take deep, even breaths until you are once again ready to exit your internal cosmos and hatch into the outside world.

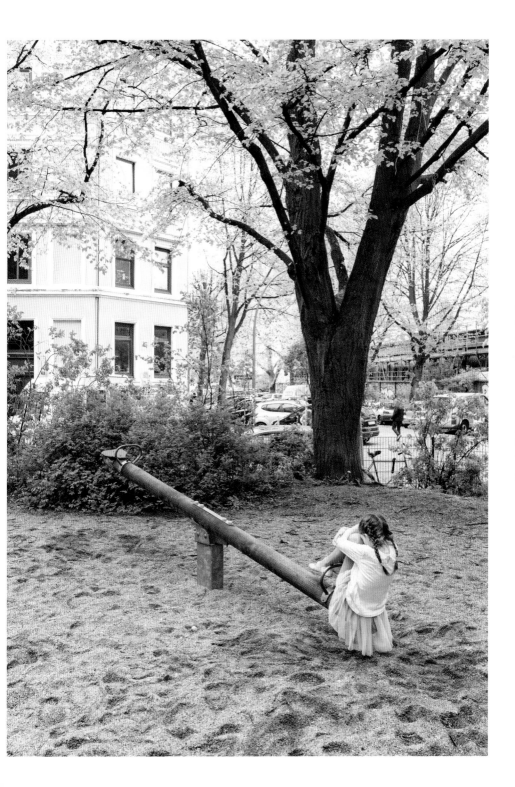

Eagle

garudasana

Waiting for release.

Promotes focus and integration. Stretches the shoulder muscles. Strengthens the leg muscles and lower back.

The bladder holds 800 ml, which equals two large sodas or a small beer. Strikingly, as soon as a certain urge becomes noticeable, the desire to relieve oneself can become unbearably urgent. However, you are invited to welcome such obstacles and delays on your way to a quick salvation as these are excellent training for the pelvic floor, balance, and mental strength. Empower your bladder and sphincters with the weightlessness and freedom of eagle pose—you will soar to a new perception of the quality in each moment, and the waiting time will fly by.

Flight instructions.
Stand straight, toes facing forward, relax your shoulders. Distribute your weight evenly on both feet and lift the arches of your feet to activate your leg muscles. Focus on a point on the horizon. Slowly shift your weight to the right foot. Cross your left leg over the right thigh and press the left ankle to the outside or back of your calf. If you can, hook your foot around the ankle. Find your balance before you bring your arms bent at a 45° angle in front of your chest, elbows touching. Bring your left arm under the right. Put your palms together and shift the whole package forward and upward, pressing the elbows together. Your shoulder blades pull down. The back remains straight. Sink a little deeper, tilting your pelvis toward the belly button to avoid stress in the lower back. Hold for five breaths and then change sides.

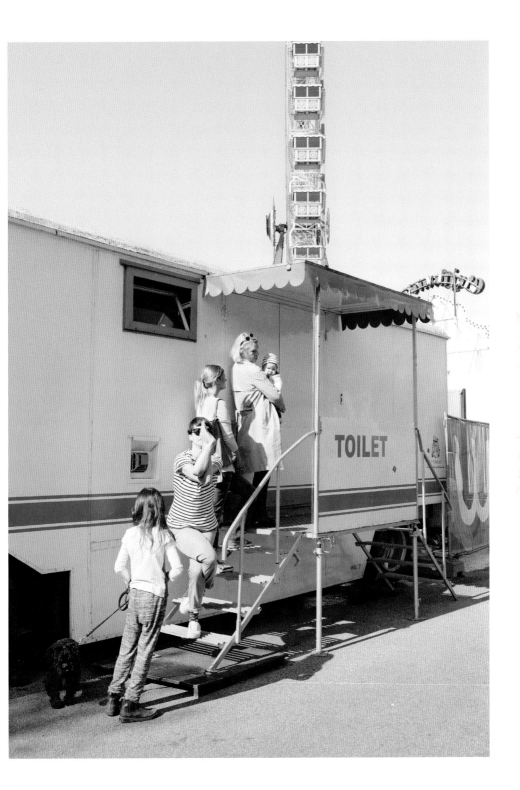

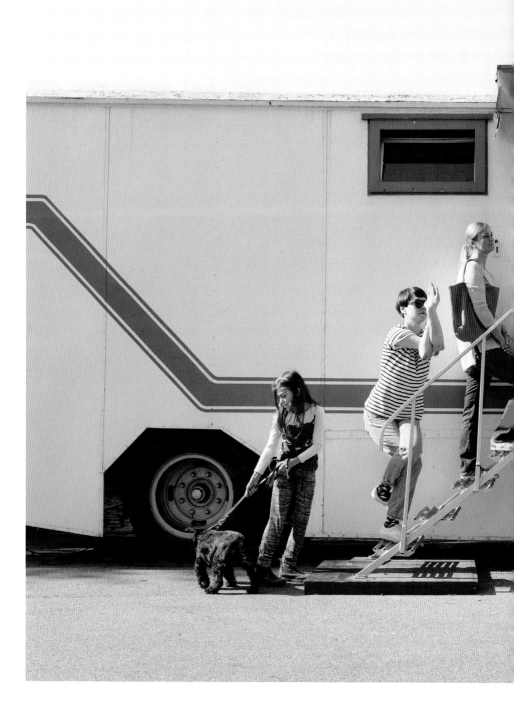

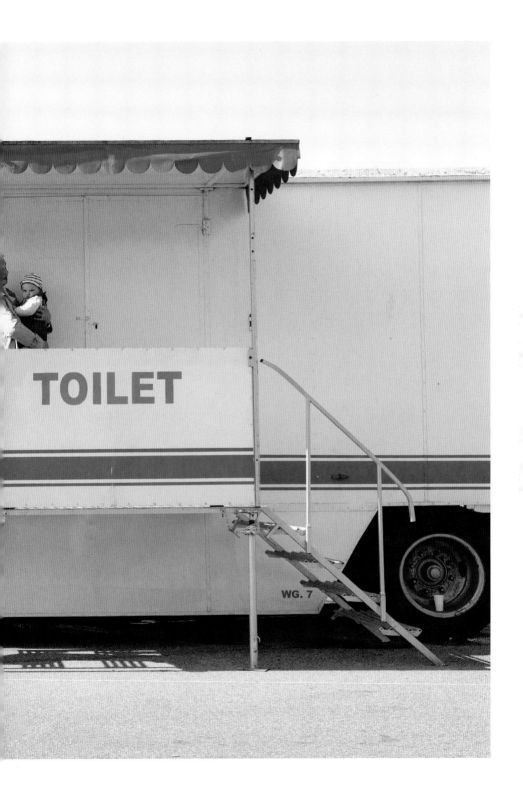

Victorious breath

ujayi pranayama

Waiting for the pizza man.

Helps you to endure unpleasant sensations and situations. Calms jumpy thoughts. Triumphs over hunger, thirst, and homesickness. Regulates blood pressure.

Your last meal is ancient history. The end of your working day is still in the distant future. But even farther away than the end of unpaid overtime is the desperately awaited arrival of the food delivery guy. When low blood sugar and mental stress grow into desperation or orgasmic fantasies, aggression, stupidity, or fainting, there is only one cure: breathe! Inhale through a narrowed throat into the weak chest and hollow belly. When the lukewarm pizza finally arrives, you will be fully energized—gas tank full, desktop empty. Bon appétit!

Inspiring patience.
To get a feeling for *ujayi pranayama* and the necessary narrowing of the glottis, exhale as if it were winter and you wanted to see your breath or whisper a few words. Then close your mouth. Breathe in and out through the nose, producing the same gentle swooshing noise. Inhale slowly, evenly, and deeply, expanding your belly first, then your chest. Exhaling, your chest flattens first and then the belly pulls in slightly. *ujayi pranayama* can be practiced in any situation, anywhere and anytime. Standing, sitting, lying, and walking—and in all of the asanas to synchronize breath and movement.

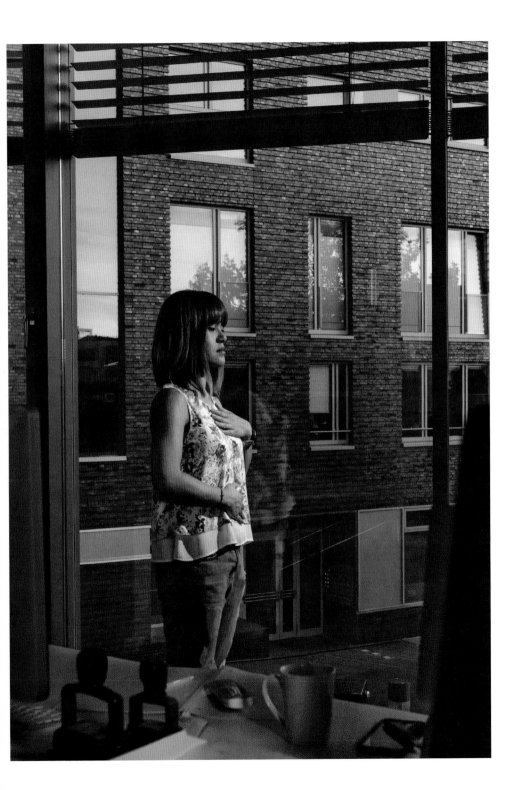

Figure 4

eka pada utkatasana

Waiting for number 79.

Good for balance and equanimity. Stretches the piriformis. Strengthens the ankles, knees, quads, buttocks, and core.

Don't allow bureaucracy to bring you to your knees. Instead, just bend your standing leg slightly to achieve remarkable effects. A legitimate combination of stretching and strengthening according to paragraph four of the Waiting Area Yoga Regulation Act, this pose prevents you from becoming a broken man or woman during your visit to the authorities. This posture, also called "one-legged chair," smoothes transitions from moment to moment to moment. If ever, one fine day, your number comes up, it will be an easy exercise to bow down deeply in front of the appropriate official in charge.

It's your turn.

Start in mountain pose (p. 28) and microbend your knees. Focus on a point on the floor in front of you or at eye level in the distance. Shift your weight onto your left leg, distributing it evenly over your whole foot. Pull your belly button toward your spine. Lift your right leg and place your ankle above your left knee. Flex your toes. Straighten your pelvis and sternum to avoid a hollow back. Press your ankle against your other leg and breathe steadily and deeply, because this may take ages. If you wish, place your hands together in front of your heart and confidently sink a little deeper. Find stability in furniture, fellow human beings, and the certainty that it will eventually be your turn—to change legs.

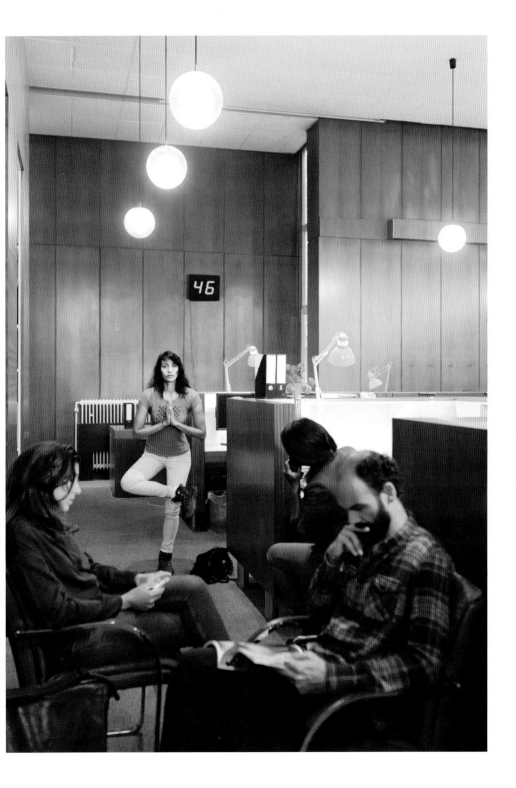

Downward facing dog

adho muka svanasana

Waiting for the lady with the schnauzer.

Stretches the back of the legs and buttocks. Strengthens the wrists, arms, and shoulders. Calms the mind.

If a man is shy and longing for connection and intimacy, he should get himself a dog. There is no better dating site than a dog park, because here Fido undertakes the challenging first sniff. An ideal choice is a dog with a dovish nature who does not drool too much. If you are an alpha male without a dog and lack any particular interest in Dalmatians, pugs, or schnauzers, you can let the ladies at the dog park come to you. While awaiting their arrival, use the time to enhance your mating-relevant secondary sexual characteristics: strong calves, powerful shoulders, and a sexy, self-composed look.

What a good doggy!
Come to all fours, with your hands below your shoulders, your knees under your hips, and your toes tucked in. Your arms should be stretched out straight, creating a lot of space between your shoulders and ears. Your back should be straight and long, your abdominal muscles active, your fingers spread with the middle fingers pointing straight ahead. Distribute your weight evenly across your palms, not just your wrists. Lift your knees off the ground and straighten your legs, pushing your buttocks up. Aim your sit bones at the sky, and reach your heels toward the ground. Your sternum wants to touch the ground, and your gaze wants to find your belly button. Your shoulders are wide and still far away from your ears. If you can't stretch your back in this position, bend your knees until you can. Wow! Bow wow!

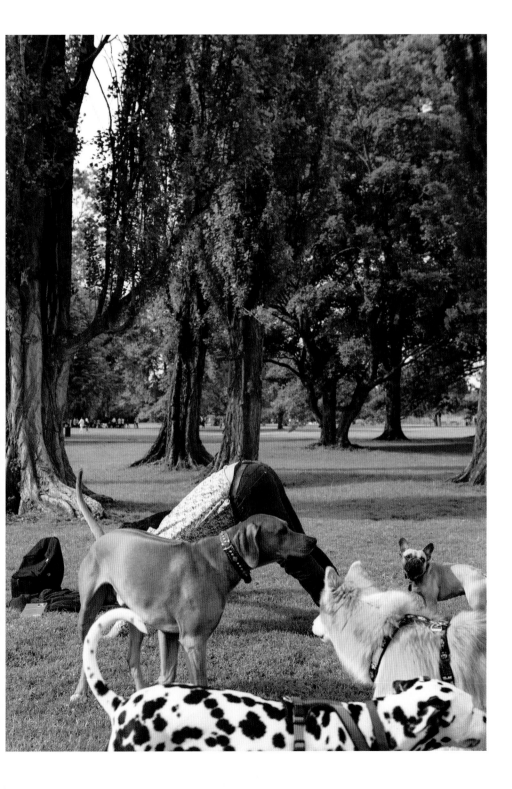

Sun salutation A

surya namaskar A

Waiting for a high.

Warms up the engines. Strengthens the body from head to toe, clears the head, and brightens the mood.

The constant complaining about gray days has to end. Because we can rely on the sun! It has been shining for 4.57 billion years without a single sick day. She always shows up for work. And until retirement, the grand old lady still has at least 5 billion years to go. So please consider this track record on a cloudy weekend or rainy summer vacation in order to maintain perspective. Use the precious moments under the cuddly blanket of clouds to say thank you to the sun. And if you are able to feel and express gratitude, the sun may shine out of the most amazing places.

Saying good morning properly.
Start in *tadasana* (p. 28). Inhaling, lift the arms overhead. If shoulders and neck allow, look up at your hands. Exhaling, bend forward, your forehead moving toward your shins—if necessary, bend your knees. Allow your hands to rest where they reach comfortably. Inhaling, lift your head and chest, straightening the back, and step back into plank. Exhaling, slowly bring the body down, elbows pointing backward. Hover close to the ground. Inhaling, straighten your arms and lift your chest and your head, gaze straight ahead. Exhaling, push the buttocks toward the sky. The back is straight, the arms are stretched with a microbend in the elbows and, if necessary, also in the knees. Inhaling, step your feet between your hands and lift your head and chest to straighten your back. Exhaling, move your chest toward your thighs and your forehead toward your shins. Inhaling, come up with a straight back. Hands to your heart. Only 107 more times!

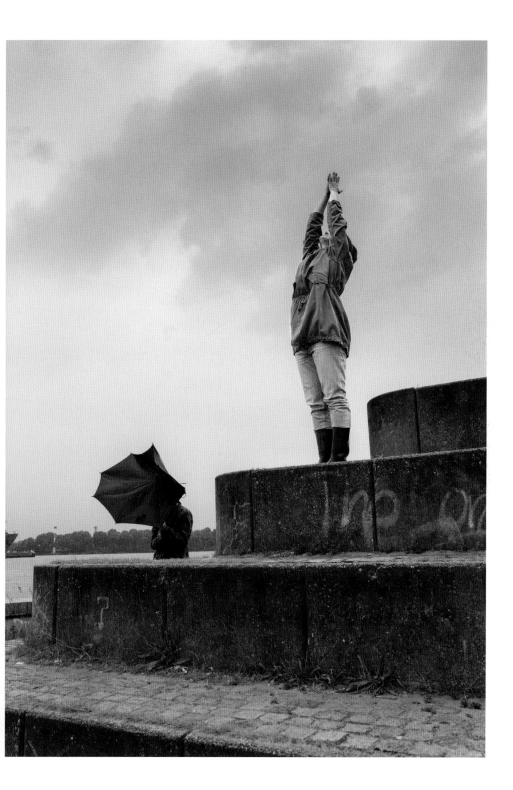

Look, sun! This is for you.

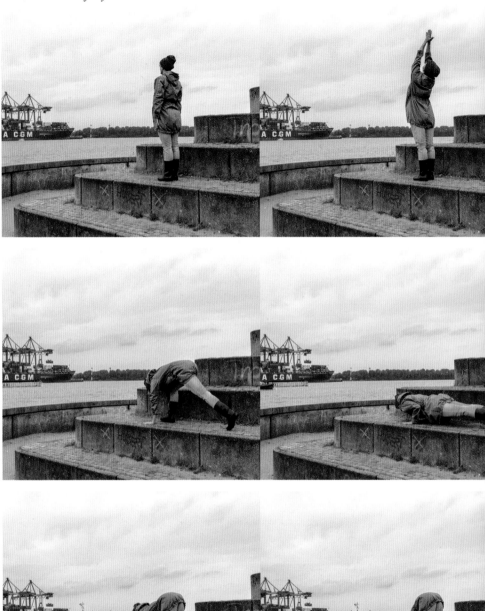
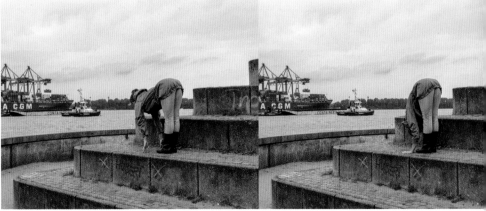

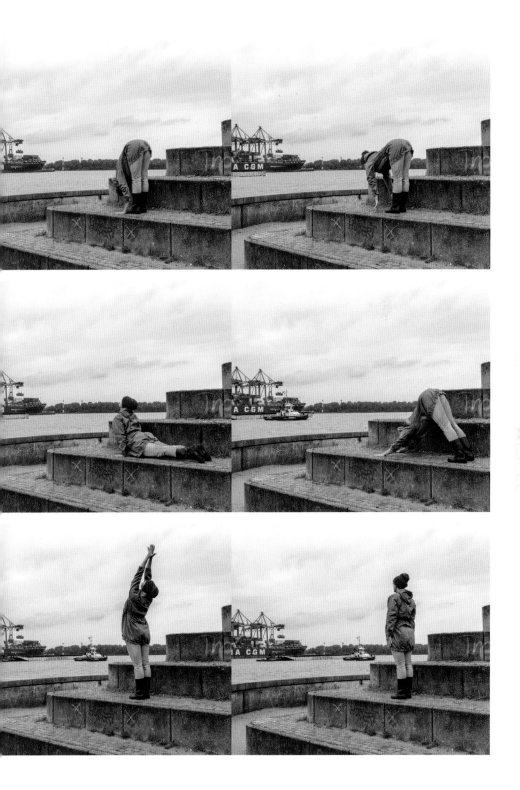

Reverse plank

purvotthanasana

Waiting for transformation.

Stretches the entire front of the body. Strengthens the wrists, arms, legs, and buttocks. Opens the chest, strengthens the shoulders, and makes you decisive.

"Become who you are." This tip for self-optimization originates from the ancient poet Pindaros (522–466 BCE). The philosopher Nietzsche (1844–1900 CE) prefaces his last writings with Pindaros's words, and—as a result of his profound self-reflection— Nietzsche becomes a madman in the Swiss Alps. At the other extreme, the superficial Narcissus drowns in a pond, madly in love with the reflection of his handsome self in the still waters. Act more wisely than these two. If you plan to employ self-reflection in your efforts to become who you are, this exercise creates an elegantly balanced arch between developing introspection and polishing your impact on others.

This is rocket science.
Check your chair for stability. Sit close to the edge. Your toes are straight, big toes touching. Place your hands on the seat, 6 inches behind your buttocks, shoulder-width apart. Fingertips may face to the front or to the back, not sideways. If you want, you can hold on to the edge of the seat. Lift the sternum and roll your shoulders back and then down. Inhaling, lift the pelvis as you straighten your arms. Without losing height, straighten one leg after the other and press your feet into the ground. Push the tailbone toward your feet. Pull your shoulder blades together, arching the back. If it feels comfortable, lower your head back, raising the chin. Hold for five long, deep breaths and then slowly touch down.

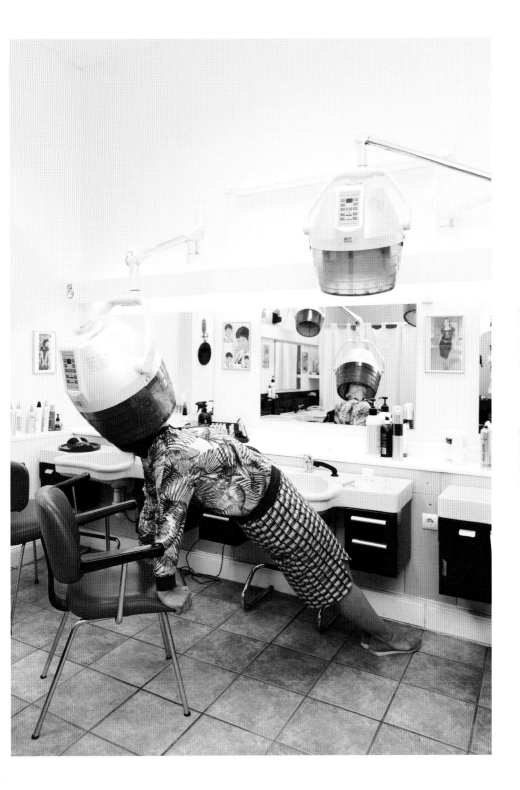

Right angle

samakonasana

Waiting for local warming.

Relieves tension and improves poise. Strengthens the upper arms, shoulders, and back.

Never skip a chance to improve your poise, and never skip a chance to improve your attitude. This includes your attitude toward frozen pizza. It is even fitting to bow deeply in front of this food. In these utterly important phases of solitude, when we lock ourselves away from the outside world to avoid distraction, the frozen pizza facilitates our contemplation. Practicing right angle pose strengthens the back so that the part-time hermit will be able to sit with a perfectly upright spine in front of his pepperoni with extra cheese. And thanks to the pizza's mandala-like shape, he will get a taste of heavenly peace in deep meditation.

Do the right thing.
Stand straight with your feet hip-width apart, your toes facing straight ahead, the outer edges of your feet parallel. Tuck your tailbone a little, pull in your belly button, lift your sternum, and roll your shoulders back. Inhale deeply, lifting your arms to the side and overhead, elongating your back and flanks. Exhale and bend forward at the hips, maintaining a straight back and neck. Extend your arms forward all the way to your fingertips, aligned with your back, elbows straight, fingers flexed. Bend your knees if it helps to keep your back straight. Rest your hands on an object in front of you if you like.

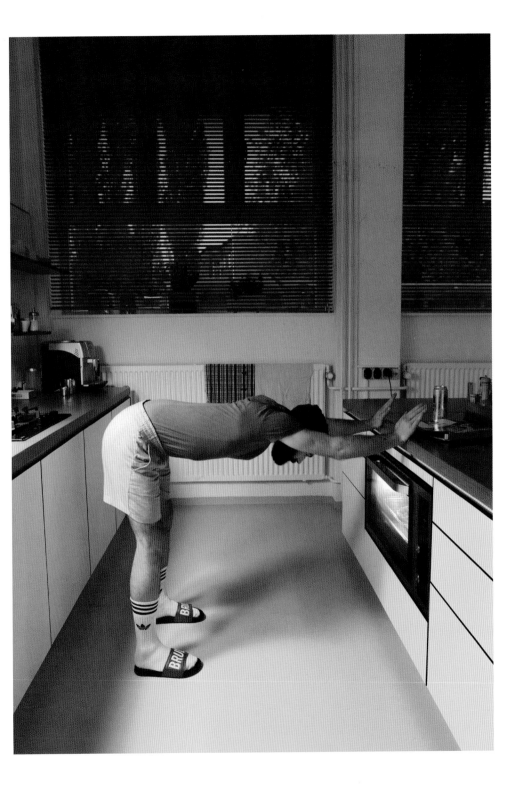

Downward facing dog II

adho mukha svanasana

Waiting for the poodle.

Promotes serenity and focus. Sharpens the senses. Comforts and soothes the heart

It's not easy being a city dog without a task. But a little practice in mindfulness that requires the downward facing dog to fully focus on breathing will help the animal to avoid feeling unfulfilled. Downward facing dog prevents dissatisfaction and/or depression by bringing the attention to the coolness of the airstream while breathing in, and to the warmth while breathing out. This allows the canine to register and appreciate, nonjudgmentally and without desire, the quality of this present moment—a moment that does not lack a thing—nothing, except an upward facing poodle, an upward facing schnauzer, or a huge bowl of goodies.

Get a grip!
Stand by the closed window with a long spine. Forepaws shoulder-width apart, hind paws hip-width apart. Let the ears and tail hang down. Stare at the window, frowning. Growl softly. Inhale and then exhale, barking loudly. Do this a minimum of three times or as long as needed to motivate the biped to open the window. Activate the hind legs and roll the shoulders back. Tense the abdominal muscles and, exhaling, shift the weight to the hind legs. Lift the forelegs and rest them on the windowsill. Breathe deeply into the belly. Back legs are stretched. Abdominals are active. Back is long and straight. Wag the tail, breathe, and hold the pose until you lose interest. Good dog!

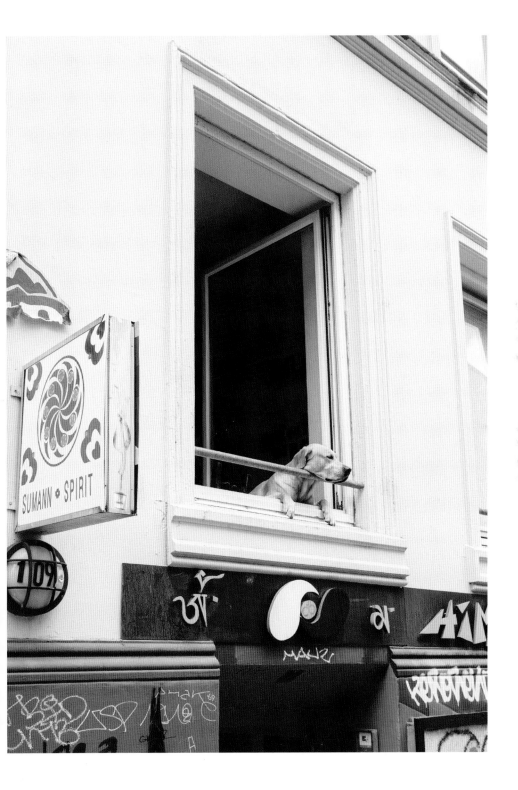

Downward facing dog.

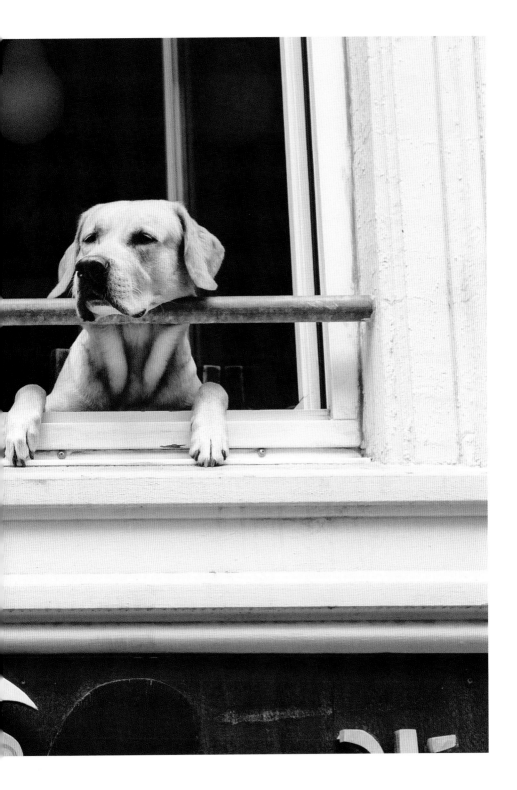

Palming

Waiting for insight.

Calms the mind. Refreshes the eyes. Clears the vision. Enhances the perception of color.

It's not easy to watch how little joy homework can bring to a child, especially when the struggling student can do the math and figure out that all his pals are out playing soccer. Despite the pluses of academic achievement, he would prefer to subtract himself from this situation. Being divided from his friends only multiplies his agony, and keeping him in his chair may become exponentially difficult (now you do the math). Consider placing your warm palms over your tired eyes for some restorative moments, taking a short break to go inside. Know that this is only a mild violation of your parental responsibilities. And if the light bulb goes off for the bright little fellow, you will still see it.

Mother's little helper.
Sit relaxed but upright. Place your feet hip-width apart, straight and parallel. Inhaling, roll your shoulders forward, then up, back, and down. Lift your sternum. Move your neck slightly back, chin parallel to the floor. Rub your palms vigorously until they get nice and warm. Place your palms over your closed eyes to create darkness, but do not put any pressure on your eyeballs. Breathe deeply and steadily. Enjoy the warmth, the silence, and the play of colors behind your eyelids. Do this for as long as you like. Anytime. Anywhere.

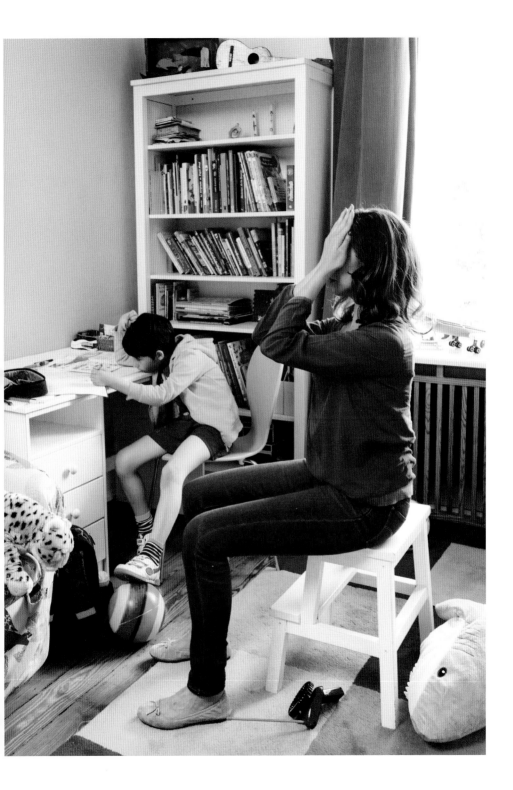

Triangle

utthita trikonasana

Waiting for the engine's roar.

Beneficial when you are stressed, anxious, or have run out of gas. Strengthens legs ps, and groin. Stretches the muscles in the back of the legs.

That's life: sometimes there is progress, sometimes there is a standstill. The universe invites owners of older vehicles to become philosophers. They can use unanticipated pauses for general inspection and to take inventory of noises, aches, and pains coming from their own aging chassis. Perhaps a check on the charge of their battery, a front tire losing air, or a warning light on the dashboard of life. Triangle will help not only motorists but all those on the road of life to face their situations squarely, head-on, and proceed to their desired destination with a perspective that is shiny and new.

Roadside assistance.
Take a wide stance, with your right foot facing straight forward and your left pointing to the side at ninety degrees, heels aligned. Stretch your arms out to the sides at shoulder level. Activate your abdominal muscles and shift your pelvis to the left. Lengthen your torso and extend over your right leg. Keeping your right arm straight, bring it toward the floor. Press your right arm against your shin as your left arm reaches for the sky, aligned with the right. Widen your collarbones and pull your lower ribs in. Look to your left hand or down at the ground, your neck aligned with your spine. Ideally, from the side you will look flat, like a hubcap. Hold for three deep breaths and then come up, engaging your abs. Warning—two-way traffic. Other side.

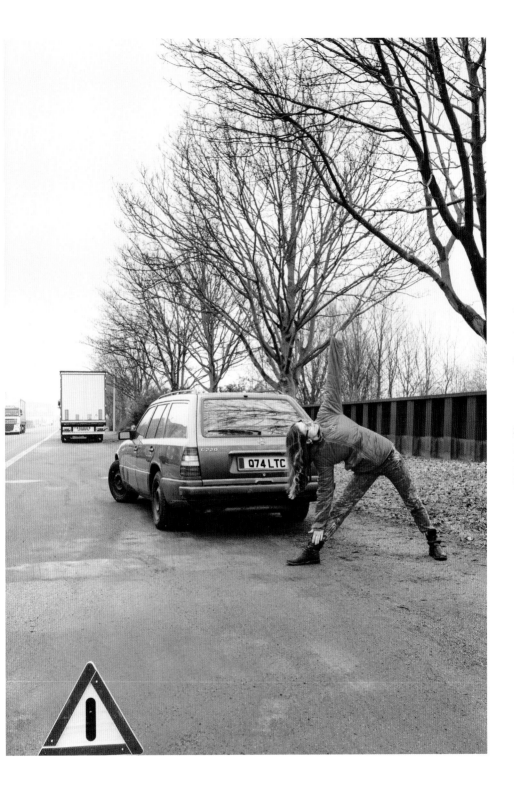

Alternate nostril breathing

anuloma viloma

Waiting for Romeo73.

Has a calming effect and strengthens inner balance.

Has the apologetic text arrived yet? Despite what the name suggests, this is not some nice guy but that part of the autonomic nervous system that creates stress when Romeo73 doesn't appear. You get nervous, anxious, and confused. Your breath becomes shallow. The lack of oxygen causes your heart to race and makes your head hurt. You sweat. But a little breathing exercise can instantly shift you over to the parasympathetic. That's not just another Romeo but a catch to hold on to: peace of mind, confidence, and the knowledge that when you are alone with yourself, you are in the best company.

In case of a Romeo no-show.
Sit relaxed with a straight back. Lift your sternum. Bring your right hand to your nose, touching your index and middle fingers gently to your third eye, that spot between your brows. Gently tap your left nostril with your ring finger and—without pressure— close your right nostril with your thumb. Close your eyes and breathe in through your left nostril, a soft and steady breath into your belly, counting to five. Release your thumb to open your right nostril and close your left nostril. Exhale through your right nostril very slowly, counting to ten. Keep your left nostril closed and inhale through your right nostril, counting to five. Close your right nostril, open your left, and exhale, counting to ten. Continue until you reach inner peace or until Romeo finally shows up.

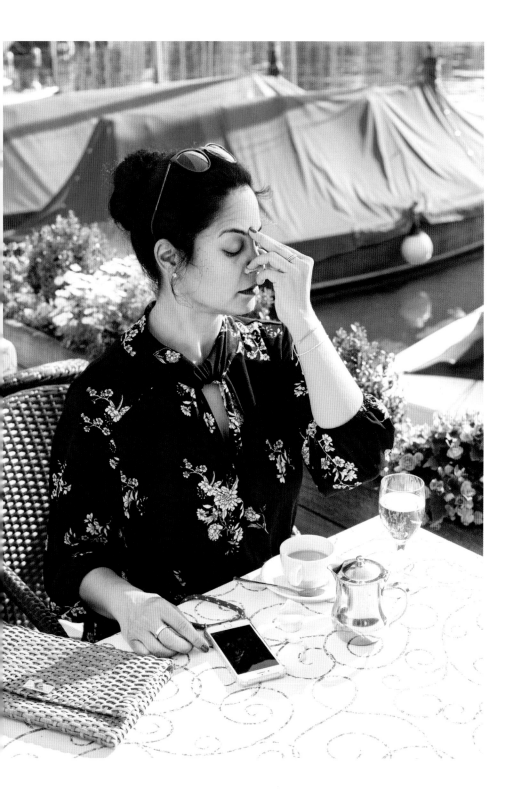

Thirty minutes later . . .

Rabbit

sasangasana

Waiting for round two.

Loosens tension in the back, shoulders, and neck. Stimulates the metabolism and endocrine system. Minimizes stress and performance anxiety.

A man who has the ability to resist getting overwhelmed in the heat of the moment during stimulating interpersonal encounters creates a smooth ride to the grand finale. Don't get impatient with interruptions or delays as you hop toward the pleasurable peak. The rabbit pose loosens you up nicely around the chest; it relaxes your head and neck and massages your thyroid, which welcomingly activates the release of hormones. When Kitty Cat comes back from the bathroom, you will rise to the occasion, mightily refreshed, and Kitty Cat will purr with appreciation.

A deeply satisfying position.
Sit on your heels, toes flat. Lift your sternum, lengthen your back, and engage your abdominal muscles. Hold your heels with your hands. Exhaling, drop your chin toward your chest and slowly bend your upper body toward the ground while lifting your hips. Press your feet and shins into the floor. Place the crown of your head as close to your knees as possible, without putting too much weight on it. Press your chin into your chest. Keep breathing! Straighten your arms behind you and hold your heels or calves in order to push your hips higher and higher, rounding your back more, more, more. Hold for five deep, deep (OMG), deep breaths. Deeper, deeper, don't stop! Slowly bring your hips back to your heels. Rest. Get in the mood for round two.

Corpse

savasana

Waiting for the spirit to move you.

Lowers blood pressure and reduces stress. Eases fatigue, insomnia, and mild depression.

It is impossible to appreciate just how wonderful it is to walk this planet. For deeper insight, it may help to close your eyes. If we lie in the dark, motionless, contemplating the exquisite beauty of the present moment, we realize what wonderful things happen without our doing anything. Birds sing. Grass grows. A flower blooms. The world spins around. Our breath rises and falls. A dog barks. Our bicycle gets stolen. The next time you find the world tiring, send it a message: "Listen, honey. I need to freshen up. See you soon. P.S., I love you."

Rest in peace.

Lie on your back. Relax. Close your eyes. If you like, you can use a blindfold for more darkness and comfort. Place your feet about hip-width apart. Let the toes fall outward. Place your arms by your sides at a 45-degree angle relative to the torso. The palms of your hands are facing upward, and the fingers are relaxed and naturally curved. Lift the pelvis from the floor, tilting the pubic bone toward the belly button, and then place the pelvis back on the floor. Lift the head and pull the chin toward the chest to create length in the neck. Gently place it down again. Consciously breathe into your belly. Try to direct your awareness to where you are. In this body. In this moment. In this world. Do this for at least 5 minutes. Before you come back, now fully alive, roll onto the right side of your body and stay here for three breaths.

When stuck between A and B, always try your best to enjoy the here and now.

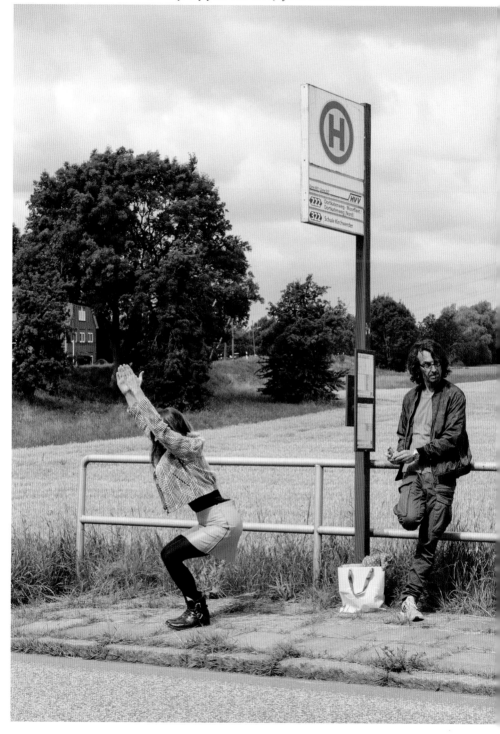

Deep forward bend

We shot the first photo on an ice-cold February morning at a bus stop in the German countryside. It was a nice morning in June when we returned to the same spot to shoot the last one. In the five months between these two photo shoots, ideas and actions, strategies and serendipities, images and words transformed into the book you now hold. We deeply appreciate all of our fabulous fellow human beings, acquaintances, colleagues, strangers, and friends who selflessly integrated our requests into their tight agendas. Our proposals to participate in a photo shoot usually came as short-notice ambushes. In addition, what we asked them to do was highly demanding in terms of flexibility—much more so mentally than physically. A double shot of courage, irony, humor, and playfulness was required. That's why two humble warriors (*baddha virabhadrasana*) bow deeply before our often first-time yogis and yoginis, without whom this book would not exist. Also, many thanks to all those who allowed us to use their premises as a stage.

Judith Stoletzky bows in gratitude to all her teachers, especially **Faramarz, John Dutch Smiling Yogi Kraijenbrink, Sudhir Rishi, Petra Algiers, Steffi Römke,** and the great **Lance Schuler.** Thank you to the photographer's **loyal automobile** and the **gods of urban parking spaces.** Thank you, **fortune**—you were absolutely reliable. The author feels more than grateful to **serendipity** and the **gift of aimless promenade,** which directed her steps to locations where the setting, the asana, and its name and benefits magically assembled into meaningful correlation and particularly amusing tableaux. So thank you to the best restaurant in the universe, the **Cox** in Hamburg; the beautiful store **Garment**; Dr. Martin Schrader's medical practice; advertising agencies **ACHTUNG** and **Karl Anders**; hair salon **Rieckhoff**; Anja Kneller and Inga Detlow's **studio | one**; and restaurant **Bobby Reich**.

About the creators

Judith Stoletzky and Markus Abele have practiced working together in the visual communications field for many years and have now mastered this "book asana" thing with their eyes closed.

The author

Judith Stoletzky is a communications designer and writer. She creates communications concepts for the advertising industry, writes for magazines and the press, and writes books. She researches truths; she makes up stories. She is constantly in search of the comical in the earnest, the lunacy in reason, and the quirky in the ordinary. If she finds it, she tells it with images and words. At the age of twelve, she attended—on motherly command—a yoga course and was not particularly impressed. It took several centuries until she began to have serious fun practicing mindful Indian gymnastics. In 2016, after many years of regular practice and studying, she completed an ashatanga-vinyasa teacher training course in India. Barely home, she couldn't wait to bring into the world her idea for *Yoga While You Wait.* Luckily, Markus Abele was in the mood to jump on board—and bring his camera along. *Yoga While You Wait* is one of four books Judith has written so far.

The photographer

Markus Abele is a communications designer and photographer. He particularly likes to focus on people doing things they love to do. He is always in search of the extraordinary in the ordinary, the unseen in the common, and the exquisite in the mundane. Despite remarkable natural flexibility and an intense first encounter with yoga while producing *Yoga While You Wait,* he does not feel a pull toward incorporating it into his life. However, he now knows the Sanskrit names of at least three asanas and is deeply sympathetic to everyone who practices yoga.

A huge thank-you to the patron saints of improvisation—where would we be without you?

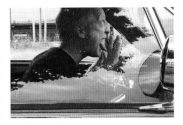
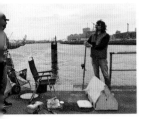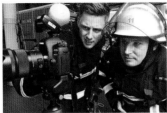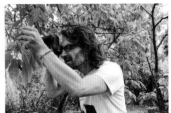
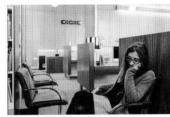
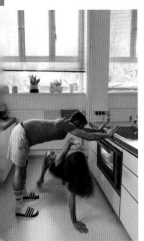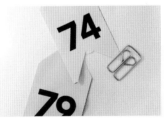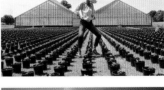
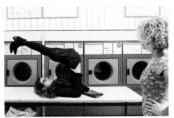

Credits

In order of appearance

Cover girl and cover boy Judith Stoletzky and Markus Abele

Chair *Sidekicks to the chair* Judith Stoletzky and Susanne Höppner

Boat *Fisherman* Sebastian Vogel

Airplane Judith Stoletzky

Shoulder stand Alexandra Schaffner

Lion *Easy rider* Olav Marquard

Half moon *Shiny* Sandra Wittwer starring Polly the pug

Warrior II Jan-Piet Stempels

Palm tree *Garden party* Jens Gebhard and Katja and Theo Evers

Mountain *Steady as a rock* Sebastian Storck

Half seated twist Tentie Fukai, Steffi Römke, Kiki, Nils Kaçirek, and Carlos Beutler

Tree Markus Abele

Hero I Henrik Liesner, Dennis (5) Zimmermann, and Dennis (11) Peters of Feuerwache 11, Hamburg

Intense dorsal stretch *Perfectly pedicured* Steffi Römke

Half bird of paradise Clemens Frede

Garland Klüver Gartenbau decorated this book with chrysanthemums

Half pyramid *Pyramidal* Ruben Rubin Scupin accompanied by very special guest Kim Arendt and impressively ignored by Torsten Lamlé

Rag doll Thuraya Hallaj with Sabine Cole, Andrea Drews, Karim Kossa, Jannick Nitz, and supermarket owner Donald "Doni" Kleinwort

Cosmic egg *Extraterrestrial* Luna June Koopmann

Eagle Julia-Christin Holtz and the patient line: Helena Bössmann, Anja Koopmann, Gustav Max Erwin Holtz, and Jackie

Victorious breath Heidi Luu

Figure 4 Betty Anwar, Ilona Benthien, Gaby Gomez de Kuhnke, and Mauricio Gomez

Downward facing dog *Wow, downward facing* Tom Lane

Sun salutation A A warm welcome for a rare visitor by Steffi Römke

Reverse plank *Spaceship* Jeanette Bergen

Right angle Hannes Petersen

Downward facing dog II Marley

Palming *Great grumpy* Raphael Kuhnke-Gomez and *peaceful* Gabriela Gomez de Kuhnke

Triangle Judith Stoletzky

Alternate nostril breathing Dewi Hutabarat

Rabbit *Soft-furred bunny* Sven Henig

Corpse Judith Stoletzky

Thank you all.

TILLER PRESS

An Imprint of Simon & Schuster, Inc.
1230 Avenue of the Americas
New York, NY 10020

English edition copyright © 2020 by Elwin Street Productions Limited

Produced by Elwin Street Productions Limited, 14 Clerkenwell Green, London, EC1R 0DP.

This publication contains the opinions and ideas of its author. It is intended to provide helpful and informative material on the subjects addressed in the publication. It is sold with the understanding that the author and publisher are not engaged in rendering medical, health, or any other kind of personal, professional services in the book. The reader should consult his or her medical, health, or other competent professional before adopting any of the suggestions in this book or drawing inferences from it.

The author and publisher specifically disclaim all responsibility for any liability, loss, or risk, personal or otherwise, that is incurred as a consequence, directly or indirectly, of the use and application of any contents of this book.

First published by Becker Joest Volk Verlag GmbH & Co. KG, Germany, © 2017.

All rights reserved, including the right to reproduce this book or portions thereof in any form whatsoever. For information, address Simon & Schuster Subsidiary Rights Department, 1230 Avenue of the Americas, New York, NY 10020.

First Tiller Press hardcover edition published in North America in March 2020.
TILLER PRESS and colophon are trademarks of Simon & Schuster, Inc.

For information about special discounts for bulk purchases, please contact Simon & Schuster Special Sales at 1-866-506-1949 or business@simonandschuster.com.

The Simon & Schuster Speakers Bureau can bring authors to your live event. For more information or to book an event, contact the Simon & Schuster Speakers Bureau at 1-866-248-3049 or visit our website at www.simonspeakers.com.

Idea, photo concept, and text by Judith Stoletzky
Photography by Markus Abele
Graphic design by Markus Abele
Translated by Judith Stoletzky and Dr. Roderick G. Syme

Manufactured in China

10 9 8 7 6 5 4 3 2 1

Library of Congress Cataloging-in-Publication Data has been applied for.

ISBN 978-1-9821-5086-0